HOW TO DRAW CARTOONS

David Antram

BOOK HOUSE

SALARIYA

Published in Great Britain in 2008 by
Book House, an imprint of
The Salariya Book Company Ltd
25 Marlborough Place, Brighton BN1 1UB

1 3 5 7 9 8 6 4 2

Please visit our website at **www.salariya.com**
for **free** electronic versions of:
You Wouldn't Want to Be an Egyptian Mummy!
You Wouldn't Want to Be a Roman Gladiator!
Avoid Joining Shackleton's Polar Expedition!
Avoid Sailing on a 19th-Century Whaling Ship!

Author: David Antram was born in Brighton,
England, in 1958. He studied at Eastbourne College of
Art and then worked in advertising for fifteen years
before becoming a full-time artist. He has illustrated
many children's non-fiction books.

Editors: Rob Walker, Stephen Haynes

PB ISBN: 978-1-906370-31-2

A CIP catalogue record for this
book is available from the
British Library.

Printed and bound in China.
Printed on paper from
sustainable sources.

**WARNING: Fixatives should be
used only under adult supervision.**

PAPER FROM
SUSTAINABLE
FORESTS

Contents

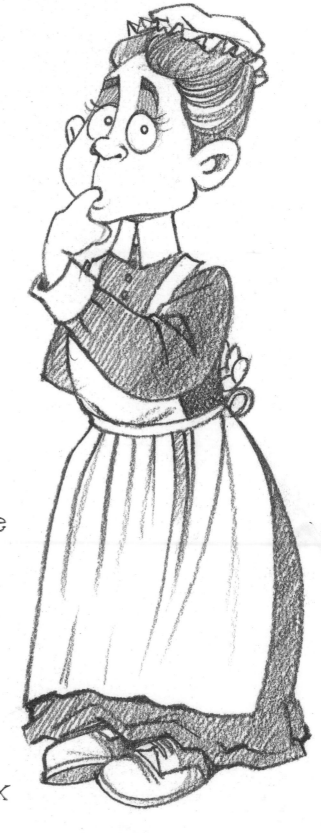

Making a start

Learning to draw is about looking and seeing. Keep practising, and get to know your subject. Use a sketchbook to make quick sketches. Start by doodling, and experiment with shapes and patterns. There are many ways to draw; this book shows one method. Visit art galleries, look at artists' drawings, see how friends draw, but above all, find your own way.

Remember that practice makes perfect. If it looks wrong, start again. Keep working at it — the more you draw, the more you will learn.

Simple shapes for the figure in action.

Perspective

If you look at any object from different viewpoints, you will see that the part that is closest to you looks larger, and the part furthest away from you looks smaller. Drawing in perspective is a way of creating a feeling of space — of showing three dimensions on a flat surface.

It may help you with perspective if you imagine your figure fitted into a rectangular block like this.

The vanishing point (V.P.) is the place in a perspective drawing where parallel lines appear to meet. The position of the vanishing point depends on the viewer's eye level. Sometimes a low viewpoint can give your drawing added drama.

V.P.

Two-point perspective drawing

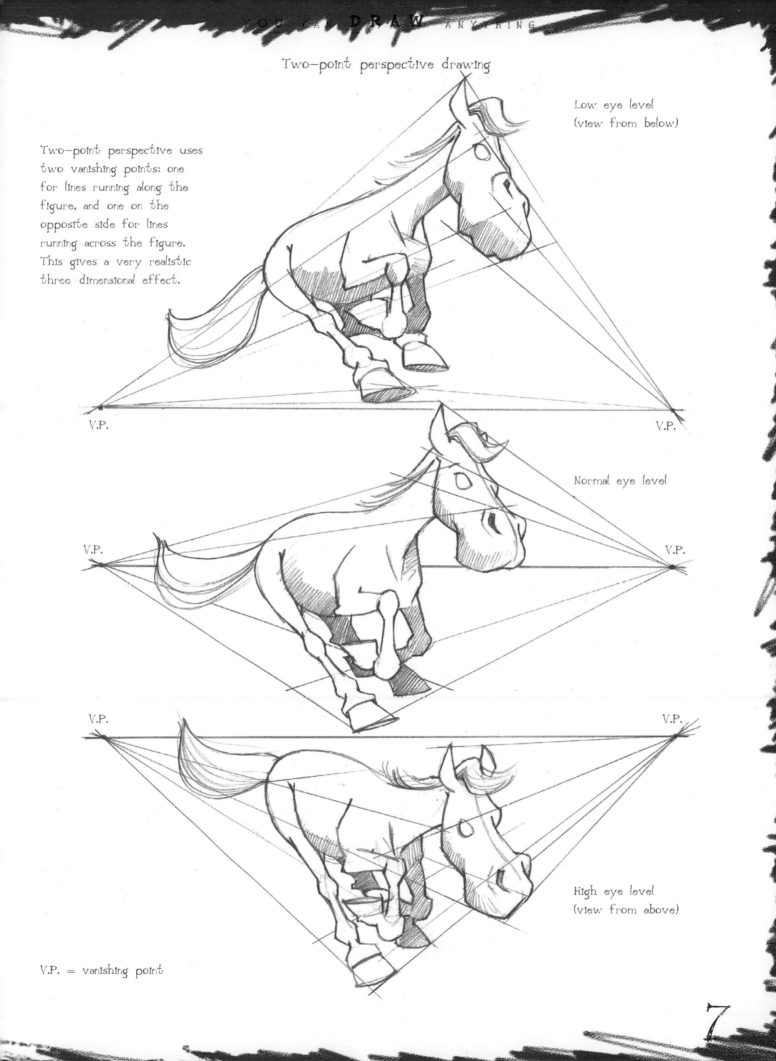

Two-point perspective uses two vanishing points: one for lines running along the figure, and one on the opposite side for lines running across the figure. This gives a very realistic three-dimensional effect.

Low eye level
(view from below)

V.P. V.P.

Normal eye level

V.P. V.P.

V.P. V.P.

High eye level
(view from above)

V.P. = vanishing point

Drawing tools

Here are just a few of the many tools that you can use for drawing. Let your imagination go, and have fun experimenting with all the different marks you can make.

Pencil

Watercolour pencil

Charcoal pencil

Charcoal stick

Pastels

Finger painting

Black, grey and white pastel on grey sugar paper

Each grade of **pencil** makes a different mark, from fine, grey lines through to soft, black ones. Hard pencils are graded as H, 2H, 3H, 4H, 5H and 6H (the hardest). An HB pencil is ideal for general sketching. Soft pencils are graded from B, 2B, 3B, 4B, 5B to 6B (the softest and blackest).

Watercolour pencils come in many different colours and make a line similar to an HB pencil. But paint over your finished drawing with clean water, and the lines will soften and run.

It is less messy and easier to achieve a fine line with a **charcoal pencil** than a stick of charcoal. Create soft tones by smudging lines with your finger. **Ask an adult** to spray the drawing with fixative to prevent further smudging.

Pastels are brittle sticks of powdered colour. They blend and smudge easily and are ideal for quick sketches. Pastel drawings work well on textured, coloured paper. **Ask an adult** to spray your finished drawing with fixative.

Experiment with **finger painting**. Your fingerprints make exciting patterns and textures. Use your fingers to smudge soft pencil, charcoal and pastel lines.

Ballpoint pens are very useful for sketching and making notes. Make different tones by building up layers of shading.

A **mapping pen** has to be dipped into bottled ink to fill the nib. Different nib shapes make different marks. Try putting a diluted ink wash over parts of the finished drawing.

Draughtsmen's pens and specialist **art pens** can produce extremely fine lines and are ideal for creating surface texture. A variety of pen nibs are available which produce different widths of line.

Felt-tip pens are ideal for quick sketches. If the ink is not waterproof, try drawing on wet paper and see what happens.

Broad-nibbed **marker pens** make interesting lines and are good for large, bold sketches. Try using a black pen for the main sketch and a grey one to block in areas of shadow.

Paintbrushes are shaped differently to make different marks. Japanese brushes are soft and produce beautiful flowing lines. Large sable brushes are good for painting a wash over a line drawing. Fine brushes are good for drawing delicate lines.

Ballpoint pen

Mapping pen

Draughtsman's pen

Felt-tip pen

Marker pen

Paintbrush

Materials

Try using different types of drawing papers and materials. Experiment with charcoal, wax crayons and pastels. All pens, from felt—tips to ballpoints, will make interesting marks. Try drawing with pen and ink on wet paper.

Ink silhouette

Felt—tips come in a range of line widths. The wider pens are good for filling in large areas of flat tone.

Pencil drawings can include a vast amount of detail and tone. Try experimenting with the different grades of pencil to get a range of light and shade effects in your drawing.

Remember, the best equipment and materials will not necessarily make the best drawing — only practice will!

ha!

Cross—hatching

Hatching

Lines drawn in **ink** cannot be erased, so keep your ink drawings sketchy and not too rigid. Don't worry about mistakes, as these can be lost in the drawing as it develops.

Adding light and shade to a drawing with an ink pen can be tricky. Use solid ink for the very darkest areas and cross—hatching (straight lines criss—crossing each other) for ordinary dark tones. Use hatching (straight lines running parallel to each other) for midtones, and keep the lightest areas empty.

11

Drawing a figure

Drawing a cartoon figure can be broken down into stages; follow the steps shown here. By learning how to build up your drawing in this way you can create your own cartoons.

Start by sketching these simple shapes.

Head

Draw an oval for the head.

Body

Draw an oval for the hips.

Draw an oval for the body and smaller ovals for the hands.

Hand

Sketch straight lines for the limbs, adding dots to show the joints.

Feet

Now start to build up the basic shape and features of your figure.

Draw a C shape to position the ear. Add straight lines for the exaggerated nose. This head is in profile (side view).

Turn the lines of the arms and legs into simple tube shapes.

Lightly sketch in the shape of the hand and outstretched fingers.

Join the ovals of the body and the hips, to get the main shape of the body.

Sketch in simple foot shapes.

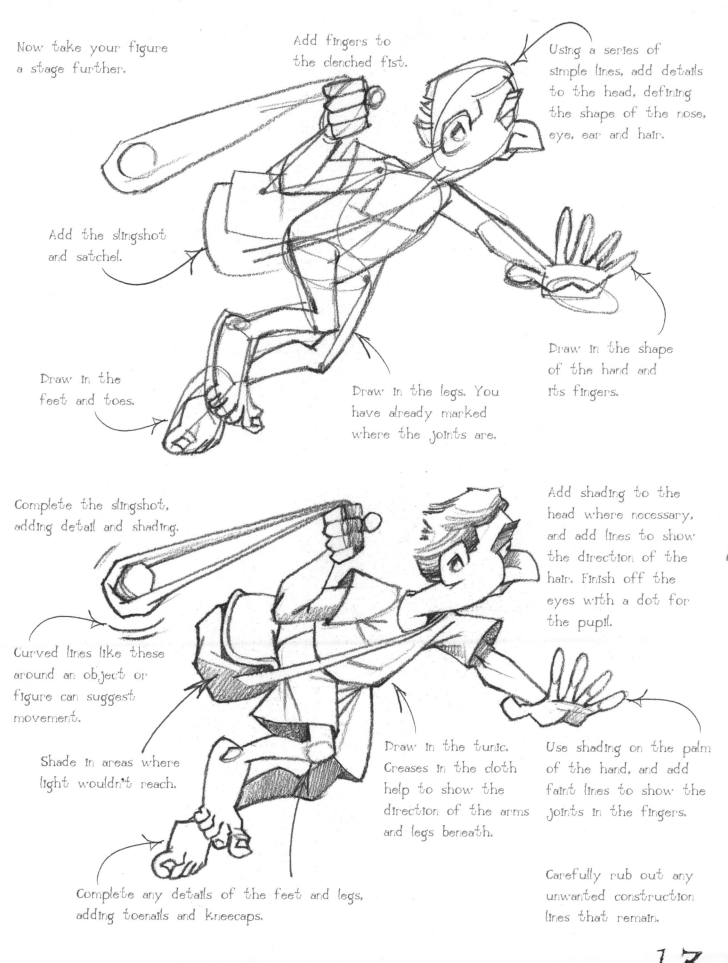

Now take your figure a stage further.

Add fingers to the clenched fist.

Using a series of simple lines, add details to the head, defining the shape of the nose, eye, ear and hair.

Add the slingshot and satchel.

Draw in the shape of the hand and its fingers.

Draw in the feet and toes.

Draw in the legs. You have already marked where the joints are.

Complete the slingshot, adding detail and shading.

Add shading to the head where necessary, and add lines to show the direction of the hair. Finish off the eyes with a dot for the pupil.

Curved lines like these around an object or figure can suggest movement.

Shade in areas where light wouldn't reach.

Draw in the tunic. Creases in the cloth help to show the direction of the arms and legs beneath.

Use shading on the palm of the hand, and add faint lines to show the joints in the fingers.

Complete any details of the feet and legs, adding toenails and kneecaps.

Carefully rub out any unwanted construction lines that remain.

13

Heads

eads come in many shapes and sizes, but this simple set of rules should help you draw any type.

First draw an oval (for a longer head and face, just make the oval longer and thinner).

Now add a narrower oval within the first. This is a construction line to show you where the centre line of the face is. The dotted part of this oval represents the back of the head.

Draw a third oval crossing the second one. This is another construction line to help you get the nose and eyes in the right place. Again, the dotted part shows the back of the head.

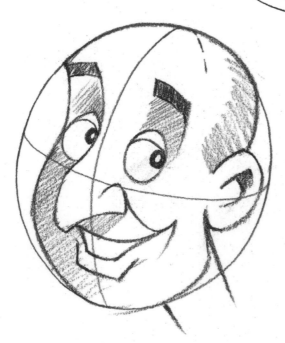

The point where the second and third ovals cross is the centre of the face. Draw in the eyes just above the centre.

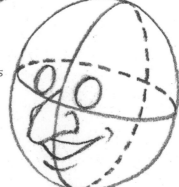

With these construction lines in place it is easier to place the facial features and draw the head.

The top of the nose, the middle of the mouth and the space between the eyes should all line up with the second oval.

You can make the head look in a different direction by changing the width of the inner ovals — this changes the position where the lines cross. This is very useful if you want to draw the same head from different angles.

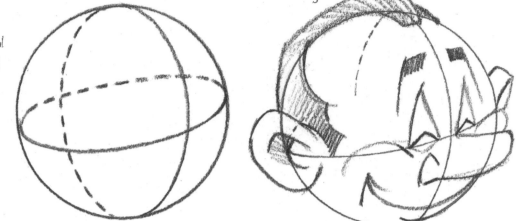

Making the second oval wider makes the head face more to the side. The cross—over construction lines always help you to identify the centre of the face.

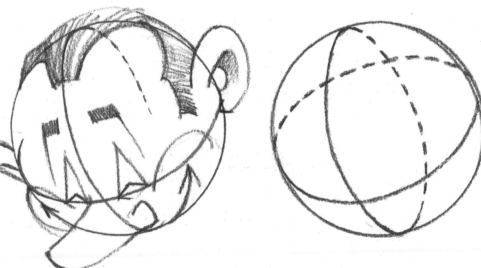

To draw a head facing downwards, the second and third ovals should cross in the lower half of the face. Use the construction lines each time to position the facial features. See how the mouth is mostly hidden by the nose.

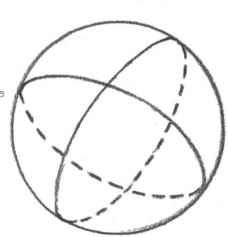

To make the head look upwards, the second and third ovals must cross in the upper half of the face. Again use the construction lines to draw in the features. See how much space the mouth takes up in this view.

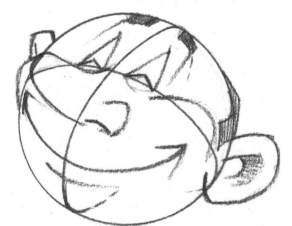

15

Expressions

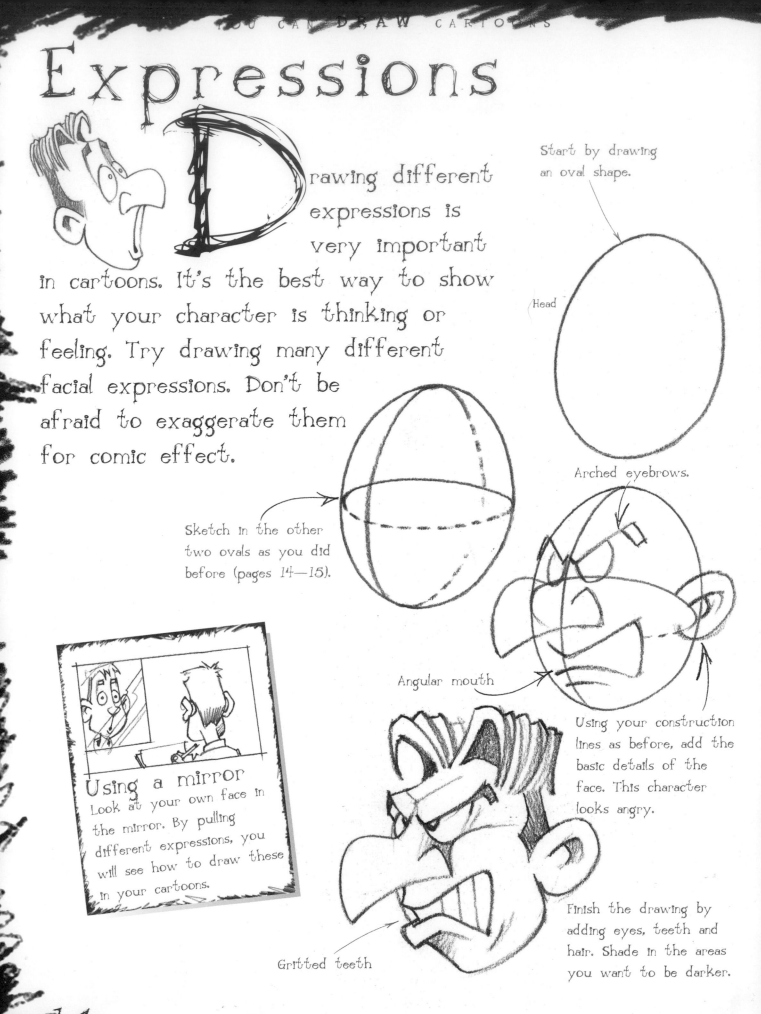

Drawing different expressions is very important in cartoons. It's the best way to show what your character is thinking or feeling. Try drawing many different facial expressions. Don't be afraid to exaggerate them for comic effect.

Start by drawing an oval shape.

Head

Sketch in the other two ovals as you did before (pages 14—15).

Arched eyebrows.

Angular mouth

Using your construction lines as before, add the basic details of the face. This character looks angry.

Using a mirror
Look at your own face in the mirror. By pulling different expressions, you will see how to draw these in your cartoons.

Gritted teeth

Finish the drawing by adding eyes, teeth and hair. Shade in the areas you want to be darker.

Now try drawing some different expressions. Here are a few ideas to get you started.

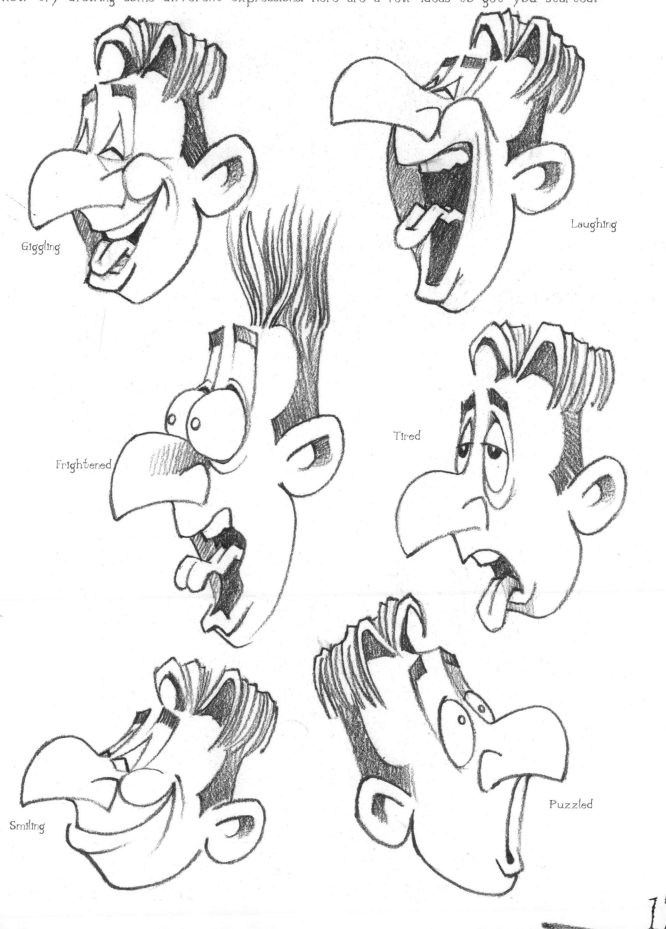

Giggling

Laughing

Frightened

Tired

Smiling

Puzzled

17

Characters

Creating different characters is fun and will expand your cartoon—drawing skills. Try to make each character different from the last. Give each one distinctive features to show their different personalities.

Start by drawing the oval construction lines for a head.

Roughly sketch in the facial features. For this character, draw the eyes quite small and close together.

Adding a hat can make a character look quite different from the others.

Make the mouth small, too.

This character's chin has been exaggerated. By drawing beyond the construction lines you can exaggerate any feature.

Start each character using the oval construction lines for the head.

This character's defining features are a long, narrow head, a large nose and a wide mouth.

This character has arched eyebrows and a wide grin.

The wide mouth has been exaggerated beyond the construction lines. This makes him look grumpy.

The eyes make this one look sneaky.

This character has high eyebrows, a narrow head and a small mouth, which make him look a bit foolish.

This character's main features are his large, beaklike nose and drooping moustache.

The narrowed eyes and crafty smile make the character look quite villainous.

Figure work

Adding clothes to a figure can help to define the character. This figure is dressed as a Victorian maid.

Start by sketching these simple shapes for the figure.

Draw an oval for the hand.

Head

Sketch an oval for the head.

Add ovals for the body and hips.

Body

Draw straight lines to connect the ovals and show the positions of the limbs.

Hips

Indicate the joints with dots.

legs

Draw two shapes for the feet.

Feet

Position the facial features as before.

Inside the hand shape, draw a circle and one finger going into the mouth.

Draw tube shapes for the arms, using your construction lines as a guide.

Join the body and hips into one large oval.

Make the legs into tube shapes.

Add a small circle for the position of the big toe. This will help you draw the shoes.

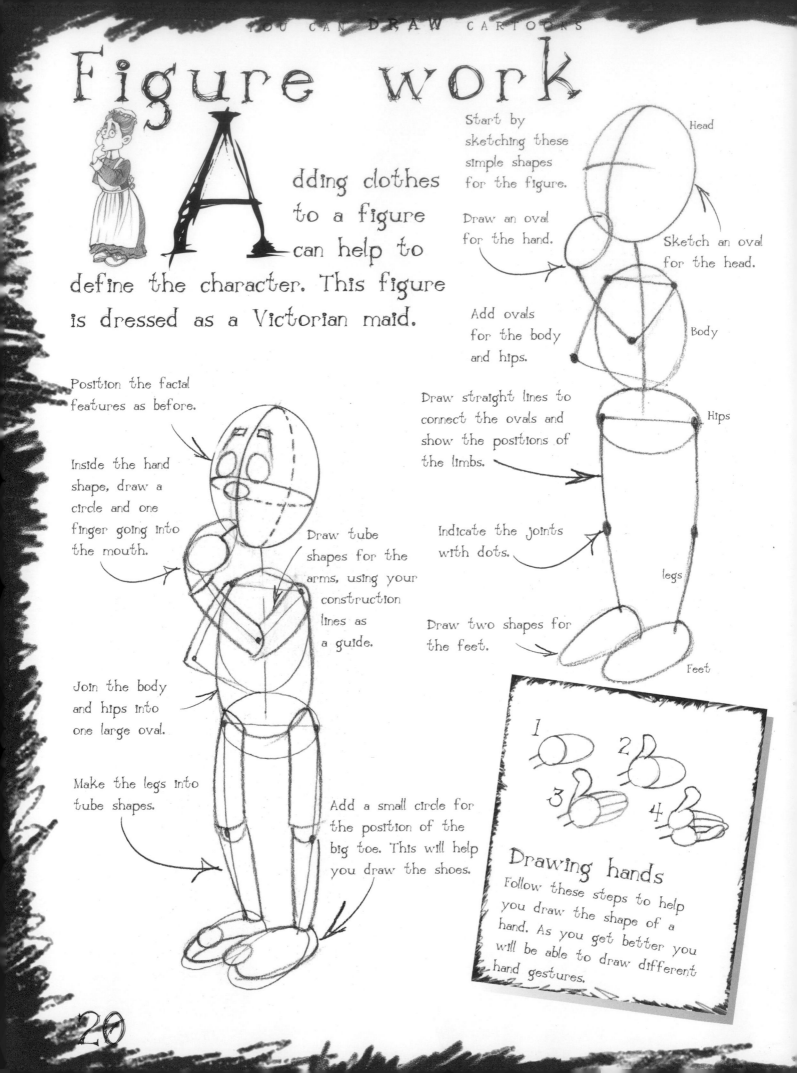

Drawing hands

Follow these steps to help you draw the shape of a hand. As you get better you will be able to draw different hand gestures.

1
2
3
4

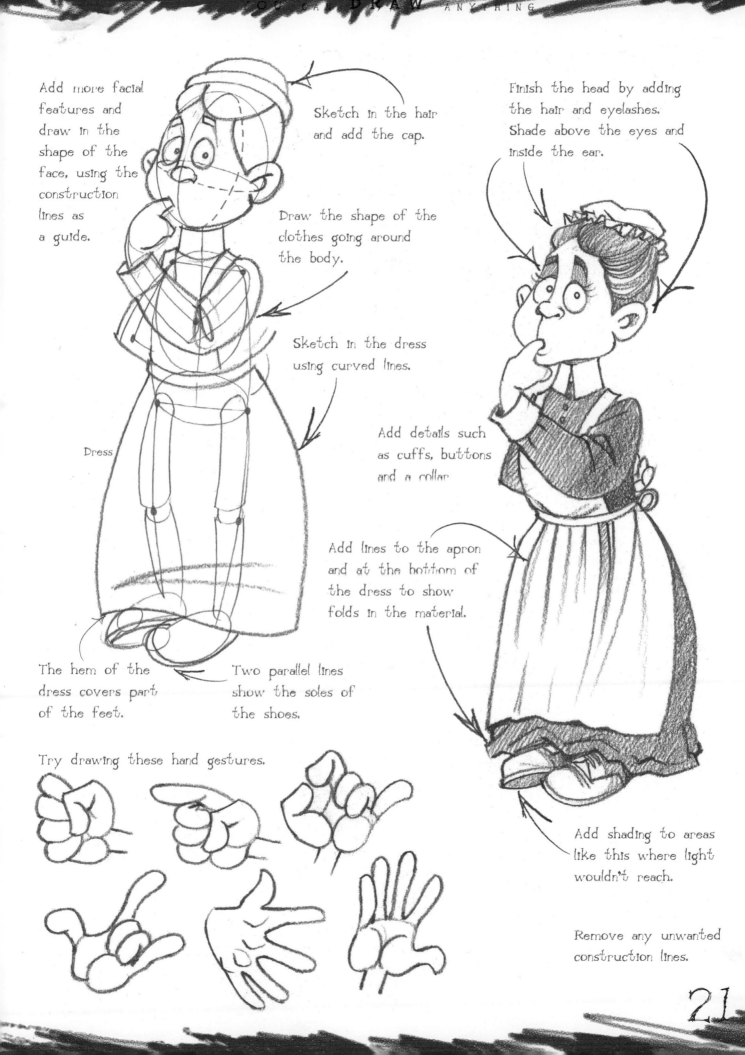

Add more facial features and draw in the shape of the face, using the construction lines as a guide.

Sketch in the hair and add the cap.

Draw the shape of the clothes going around the body.

Sketch in the dress using curved lines.

Dress

Add details such as cuffs, buttons and a collar.

Add lines to the apron and at the bottom of the dress to show folds in the material.

The hem of the dress covers part of the feet.

Two parallel lines show the soles of the shoes.

Try drawing these hand gestures.

Finish the head by adding the hair and eyelashes. Shade above the eyes and inside the ear.

Add shading to areas like this where light wouldn't reach.

Remove any unwanted construction lines.

21

Figure in costume

This cartoon character is an Inca warrior. With his costume and weapons he cuts a very distinctive figure.

A straight line with an oval on top shows the position of the club.

Head

Sketch the main shapes of the figure.

Club

Use ovals for the head, body, hands and hips.

Body

Add a straight line for the staff.

Hips

Indicate the joints with dots.

legs

Sketch in the features of the face. The most prominent features are his large nose and downturned mouth. Use the construction lines to help place the eyes, nose and mouth.

Feet

Start to sketch in the shape of the hand.

Draw curved shapes for the position of the feet.

Make the body and hips into one large oval.

Draw in tube-shaped arms and legs. Remember, the dots show where the joints are.

The headdress is made up of diamond shapes. Sketch these along the top of the head.

Extend the shape of the face beyond the construction lines and add more detail to the eyes.

Each of the diamond shapes needs a line down the centre to make it look like a feather.

Sketch in curved lines to draw the club.

Draw in the fingers.

Draw a large circle for the medallion.

Add more detail to the face.

Start sketching in clothes, using simple shapes.

A few wavy lines make the medallion look reflective.

Draw lines down the club to give it a wood effect.

Add toes and sandals to the feet.

Shade alternate squares on the warrior's tunic.

Shade areas like this where light wouldn't reach.

Complete the details of the feet and sandals.

Add lines to show costume detail.

Remove any unwanted construction lines.

23

Monster

This cartoon monster has just been awakened by a massive jolt of lightning. Adding backgrounds and effects like these can bring your drawing to life, too!

Start by sketching in the shape of the figure as it sits bolt upright.

Sketch in simple shapes for the hands and thumbs.

Head

Body

Hand

Arm

This monster has no neck, so overlap the oval of the head with the oval for the body.

Add straight lines for the arms and legs, with dots to indicate the joints.

Draw in a line to show the position of the bench.

Draw a curved line to make a flat top for the monster's head.

Add some basic facial features, using circles for the eyes and the nose.

Sketch in tube-shaped arms and legs, adding a circle for each knee.

Sketch in the shape of the monster's feet, adding a big toe too.

Sharp, spiky lines coming from the monster show the bolt of electricity.

Add detail to the face. Shading above the eyes makes the brow jut forward.

Draw the monster's sleeves with his arms poking out, to exaggerate his size

Sketch in fingers.

Add the rest of the toes and draw in toenails.

Draw a belt around the monster's waist.

Draw more lines to create the bench.

Finish the detail of the head.

Shading makes the lightning bolt look brighter.

Add stitches to the monster's wrists and forehead.

Finish the details of the hands, adding fingernails and knuckles.

Add shading and creases to the monster's clothes.

Finish drawing the bench.

Remove any unwanted construction lines.

Rats

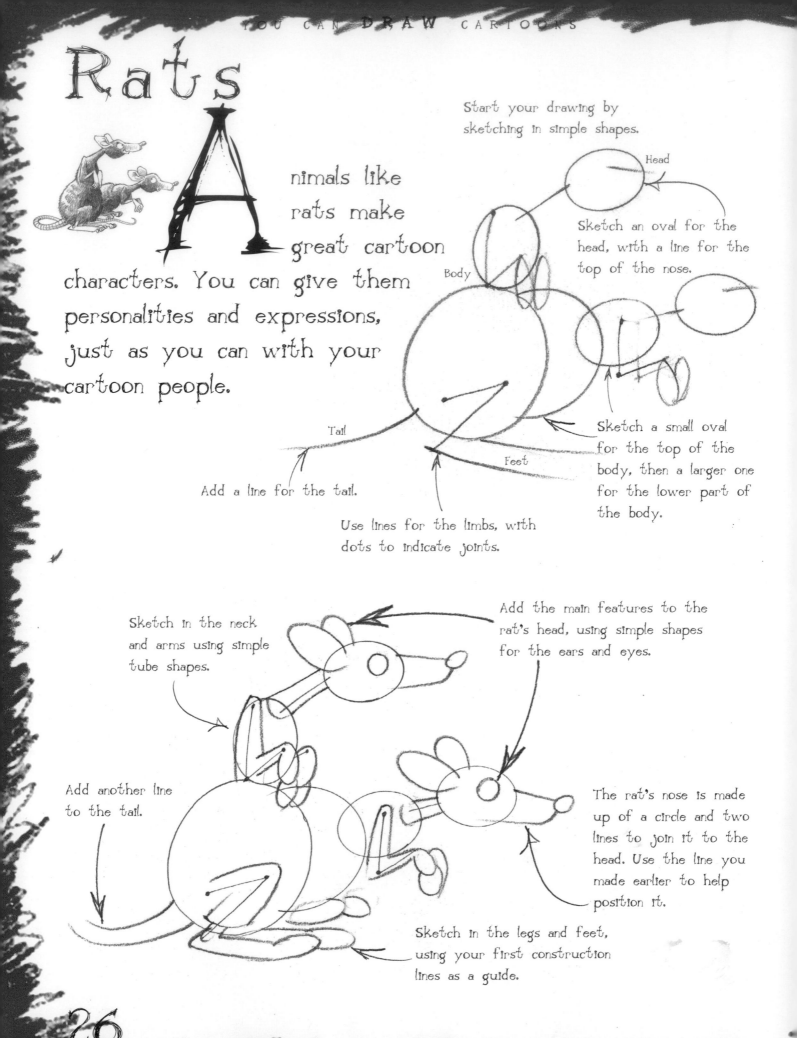

Animals like rats make great cartoon characters. You can give them personalities and expressions, just as you can with your cartoon people.

Start your drawing by sketching in simple shapes.

Head

Sketch an oval for the head, with a line for the top of the nose.

Body

Tail

Feet

Add a line for the tail.

Use lines for the limbs, with dots to indicate joints.

Sketch a small oval for the top of the body, then a larger one for the lower part of the body.

Sketch in the neck and arms using simple tube shapes.

Add the main features to the rat's head, using simple shapes for the ears and eyes.

Add another line to the tail.

The rat's nose is made up of a circle and two lines to join it to the head. Use the line you made earlier to help position it.

Sketch in the legs and feet, using your first construction lines as a guide.

26

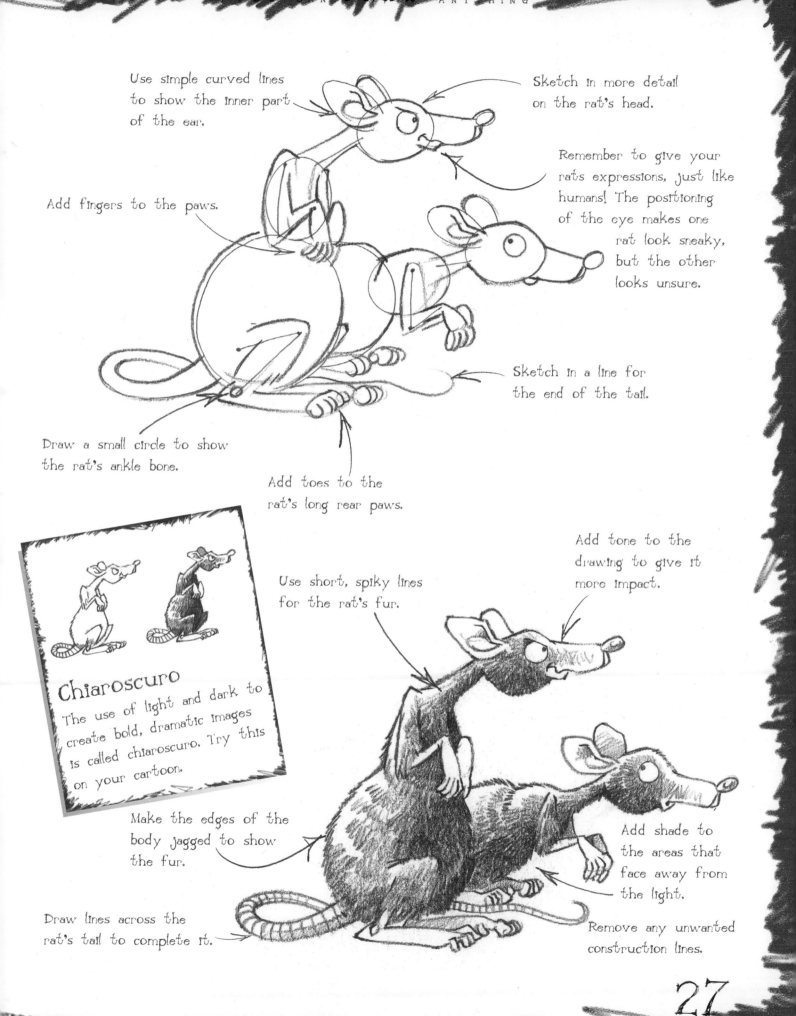

Use simple curved lines to show the inner part of the ear.

Sketch in more detail on the rat's head.

Remember to give your rats expressions, just like humans! The positioning of the eye makes one rat look sneaky, but the other looks unsure.

Add fingers to the paws.

Sketch in a line for the end of the tail.

Draw a small circle to show the rat's ankle bone.

Add toes to the rat's long rear paws.

Add tone to the drawing to give it more impact.

Use short, spiky lines for the rat's fur.

Chiaroscuro
The use of light and dark to create bold, dramatic images is called chiaroscuro. Try this on your cartoon.

Add shade to the areas that face away from the light.

Make the edges of the body jagged to show the fur.

Draw lines across the rat's tail to complete it.

Remove any unwanted construction lines.

Bulldog

The bulldog is a classic cartoon character. Its face is perfect for a grumpy expression, which instantly gives it a character all of its own.

Mark in the positions of the ears and the nose.

The main shape of the bulldog is made with different-sized overlapping circles.

Draw a short line for the tail.

Body

Legs

Add short, curved lines for the legs.

Draw in the shape of the ears.

Add circles for the eyes, with straight lines above to make them look more aggressive.

Using the construction lines as a guide, add in the mouth and jowls.

Join the two circles of the body with straight lines.

Sketch in two curved lines for the neck and collar.

Add in the front legs and paws.

This foot is upturned, so you only see the sole. Sketch this in as a simple shape.

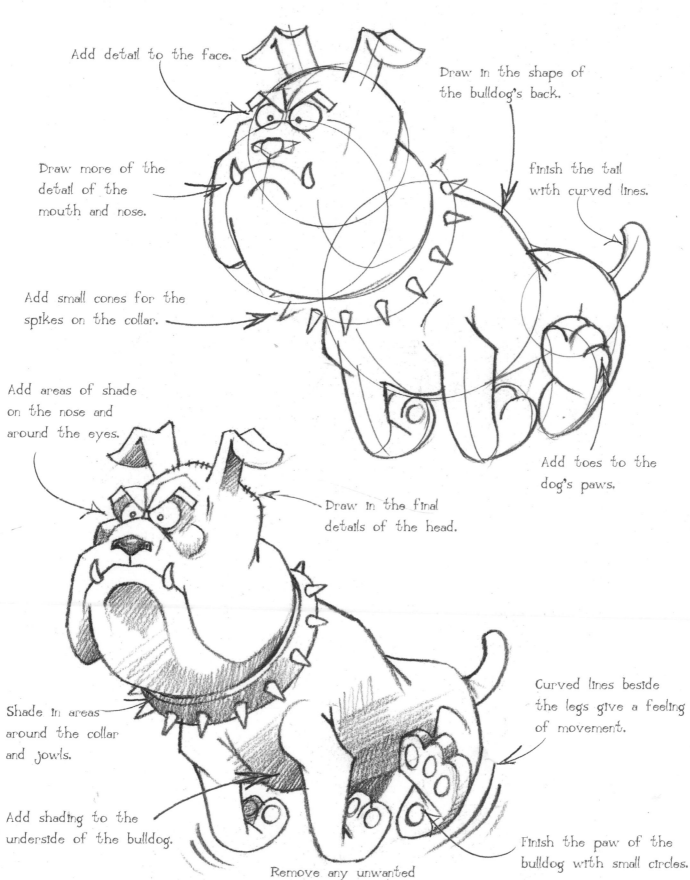

Add detail to the face.

Draw in the shape of the bulldog's back.

Draw more of the detail of the mouth and nose.

finish the tail with curved lines.

Add small cones for the spikes on the collar.

Add areas of shade on the nose and around the eyes.

Draw in the final details of the head.

Add toes to the dog's paws.

Curved lines beside the legs give a feeling of movement.

Shade in areas around the collar and jowls.

Add shading to the underside of the bulldog.

Remove any unwanted construction lines.

Finish the paw of the bulldog with small circles.

29

Man on a donkey

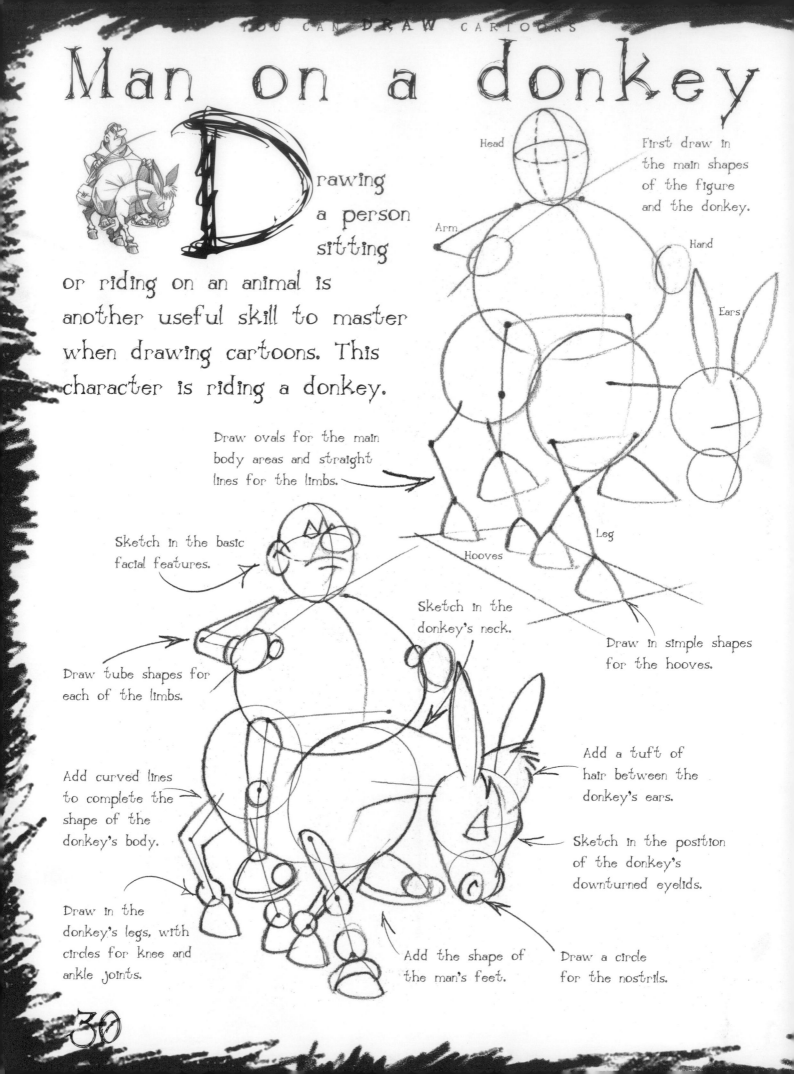

Drawing a person sitting or riding on an animal is another useful skill to master when drawing cartoons. This character is riding a donkey.

First draw in the main shapes of the figure and the donkey.

Head

Arm

Hand

Ears

Leg

Hooves

Draw ovals for the main body areas and straight lines for the limbs.

Sketch in the basic facial features.

Draw tube shapes for each of the limbs.

Sketch in the donkey's neck.

Draw in simple shapes for the hooves.

Add curved lines to complete the shape of the donkey's body.

Add a tuft of hair between the donkey's ears.

Sketch in the position of the donkey's downturned eyelids.

Draw in the donkey's legs, with circles for knee and ankle joints.

Add the shape of the man's feet.

Draw a circle for the nostrils.

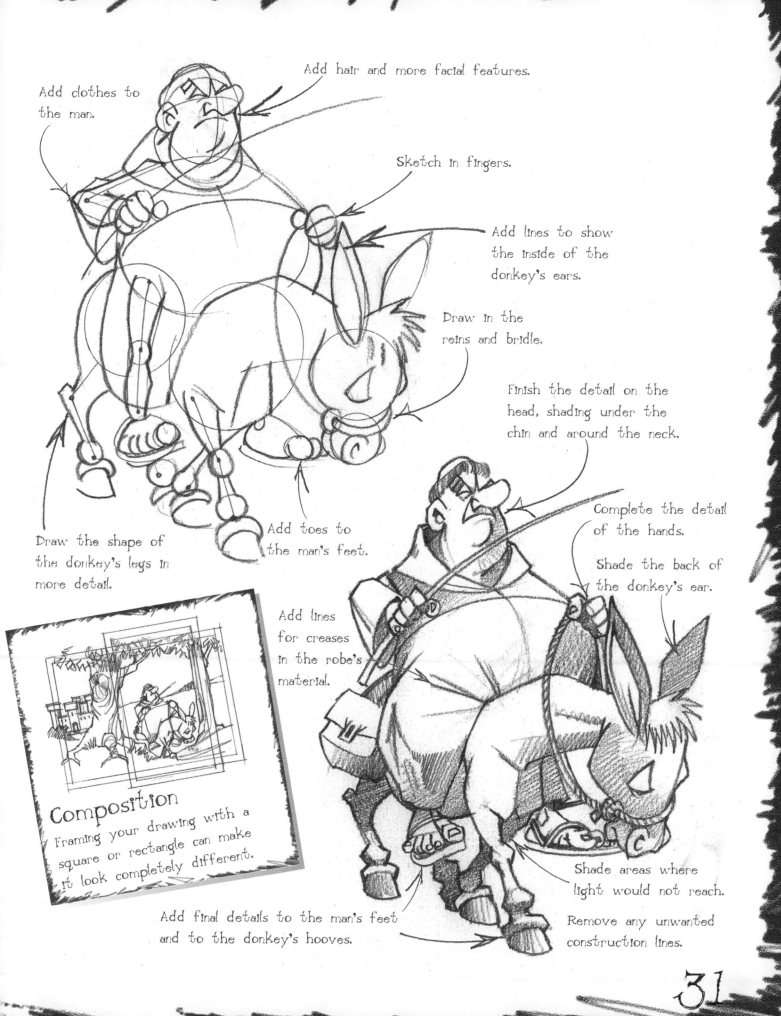

Add clothes to the man.

Add hair and more facial features.

Sketch in fingers.

Add lines to show the inside of the donkey's ears.

Draw in the reins and bridle.

Finish the detail on the head, shading under the chin and around the neck.

Draw the shape of the donkey's legs in more detail.

Add toes to the man's feet.

Complete the detail of the hands.

Shade the back of the donkey's ear.

Add lines for creases in the robe's material.

Composition

Framing your drawing with a square or rectangle can make it look completely different.

Add final details to the man's feet and to the donkey's hooves.

Shade areas where light would not reach.

Remove any unwanted construction lines.

31

Glossary

Chiaroscuro The use of light and dark in a drawing.

Composition The positioning of a picture on the drawing paper.

Construction lines Guidelines used in the early stages of a drawing, and usually erased later.

Cross-hatching A series of criss-crossing lines used to add shade to a drawing.

Fixative A type of resin used to spray over a finished drawing to prevent smudging. **It should only be used by an adult.**

Hatching A series of parallel lines used to add shade to a drawing.

Light source The direction from which the light seems to come in a drawing.

Profile A view from the side, especially a side view of a person's head or face.

Reference Photographs or other images used to help produce a drawing, if drawing from life is not possible.

Silhouette A drawing that shows only a dark shape, like a shadow.

Three-dimensional Having an effect of depth, so as to look lifelike or real.

Vanishing point The place in a perspective drawing where parallel lines appear to meet.

Index